A Keepsake

PORTLAND, MAINE

Antelo Devereux Jr.

SCHIFFER PUBLISHING

4880 Lower Valley Road • Atglen, PA 19310

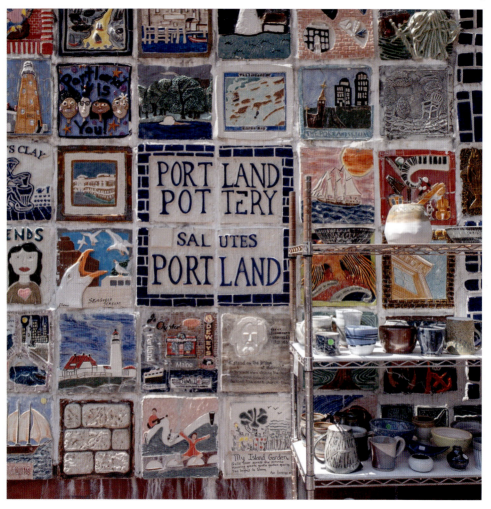

Portland Pottery, Washington Street

INTRODUCTION

Machigonne (great neck) was the Native Americans' name before English settlers called their fishing and trading village Casco, and when the Massachusetts Bay Colony took over, it became Falmouth. That village was destroyed in 1676 by the native Abenaki during King Philip's War. After having been rebuilt, it was destroyed again by the members of a French raiding party along with their Native American allies during the battle of Fort Loyal. Falmouth was attacked and burned yet again, this time by the British in 1775. Following the American Revolution, the Neck section of Falmouth was developed as a commercial port along the Fore River and appropriately was named Portland.

During the nineteenth century, Portland grew to be an important and prosperous port and manufacturing center. Key to its development was railroad access to it from the inland areas. The Atlantic and St. Lawrence Railroad's connection to Montreal allowed the harbor to serve as an ice-free port for Canada during the winter. The Portland Company emerged as the largest business in the city and became a key source of locomotive engines, 160 merchant and naval vessels, railcars, construction equipment, and other key transportation equipment. Remnants of the company can be found along the waterfront in the east end of the city. Ultimately five railroads terminated in Portland, an indication of the port's importance during its heyday.

One of the visual hallmarks of nineteenth-century Maine is the use of brick and granite for commercial buildings. Portland's Old Port area has many of them, primarily as a result of the rebuilding that followed the great fire of 1866, which burned most of the commercial buildings, half the churches, and hundreds of houses, leaving ten thousand people homeless.

During the first half of the twentieth century, Portland languished as Maine's economy sagged. However, gradually the tide has turned, and the city has evolved into a tourist destination as well as a corporate and financial center for Maine. Restaurants flourish, hotels abound, and large cruise ships visit to allow their passengers to sample the offerings of the largest city in Maine, especially when fall colors decorate New England trees. The city also has a vibrant cultural scene for the visual arts, centered on the Maine College of Art & Design and the Portland Art Museum. Merrill Auditorium is the primary venue for the Portland Symphony and Opera Maine.

Portland is friendly and walkable, with many sights from the past to the present. The city has successfully created a dynamic mixed-use waterfront. Housing, hotels, office space, and restaurants coexist with fishing boats and commercial wharves—the sounds of seagulls are a reminder that the town has an active working port. Schooners and cruise ships come and go as ferry boats carry passengers to and from their houses and hotels on several islands in Casco Bay.

I hope the ninety or so photographs on the pages that follow give the reader a taste of Portland as enjoyable as have been my walks about town in search of images to capture.
—ADJr

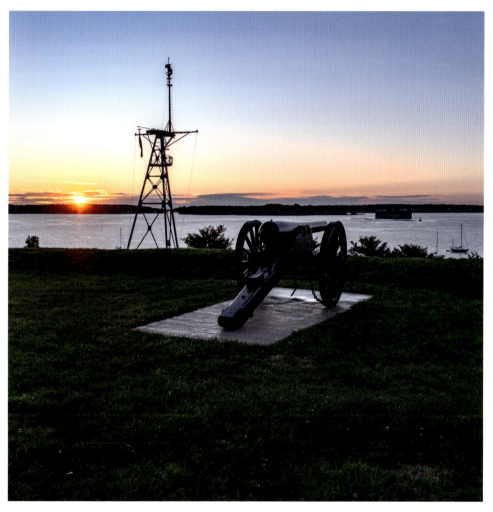

East end, Fort Allen Park

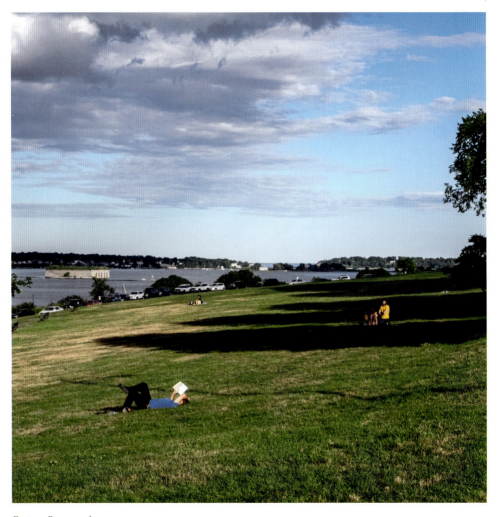

Eastern Promenade

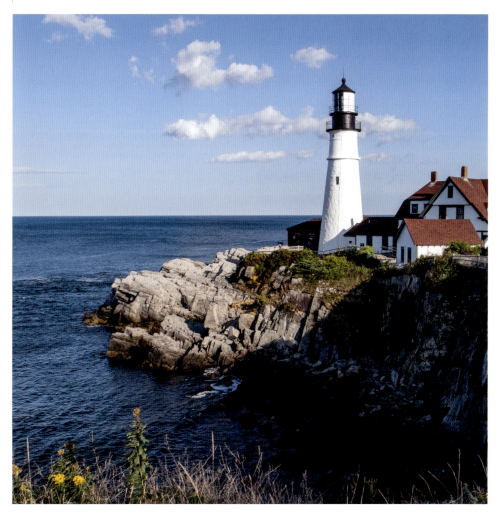

Portland Head Lighthouse, Cape Elizabeth

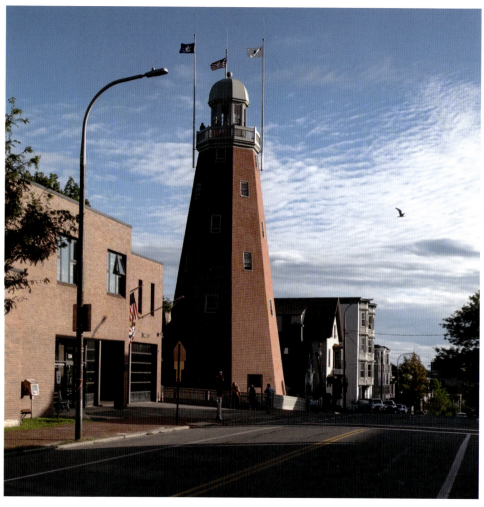

Munjoy Hill, Portland Observatory, Congress Street

Munjoy Hill, Congress Street

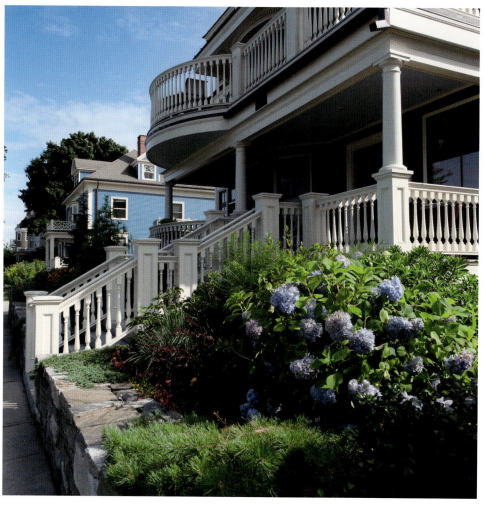

Eastern Promenade

Washington Street

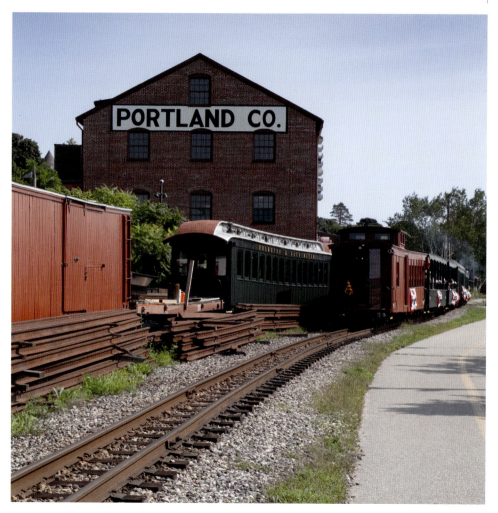

Maine Narrow-Gauge Railroad, Eastern Promenade Trail

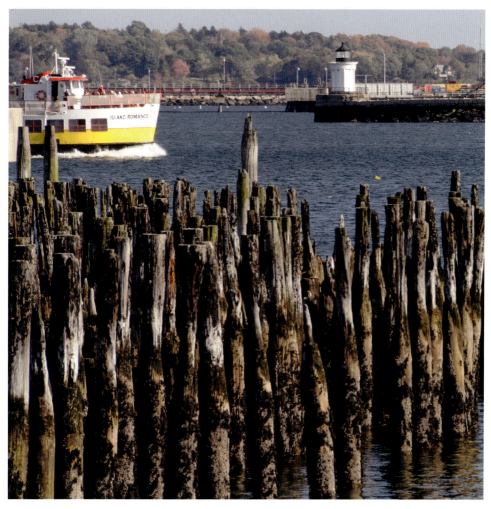
Along Eastern Promenade Trail

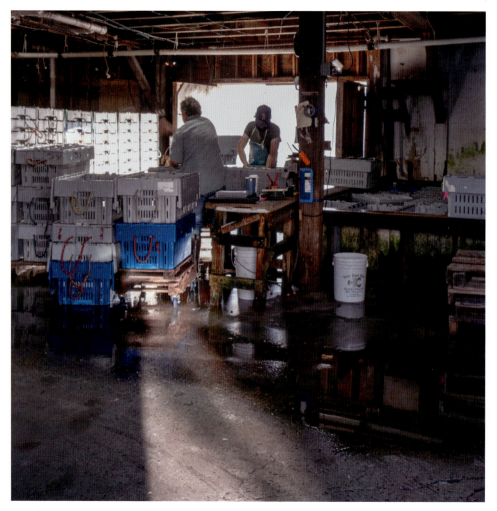

Custom House Wharf

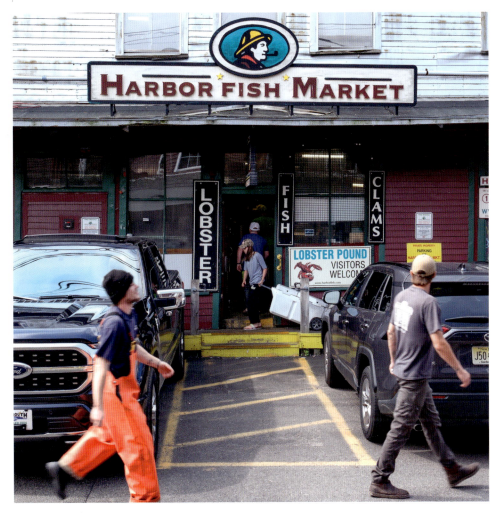

Harbor Fish Market, Custom House Wharf

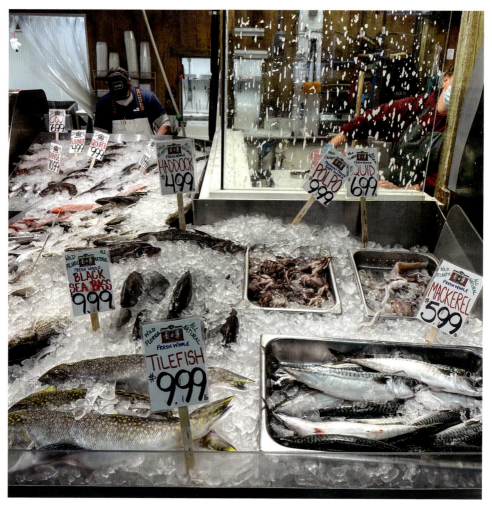

Harbor Fish Market, Custom House Wharf

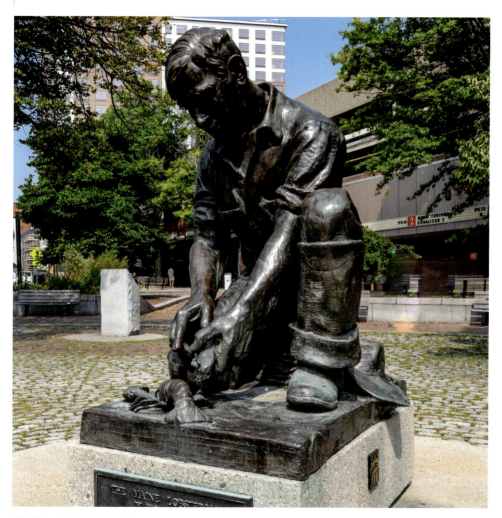

The Maine Lobsterman, Lobsterman Park, Temple Street

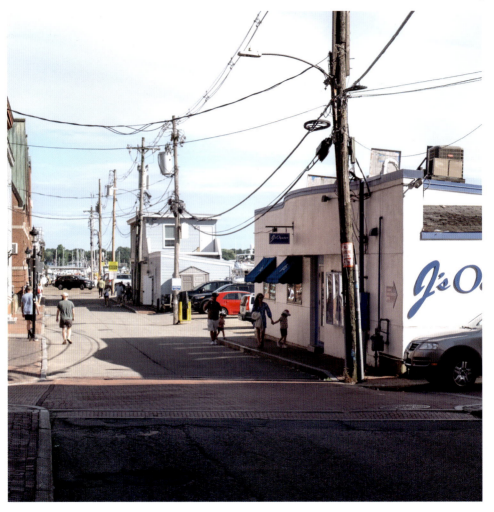

Portland Pier

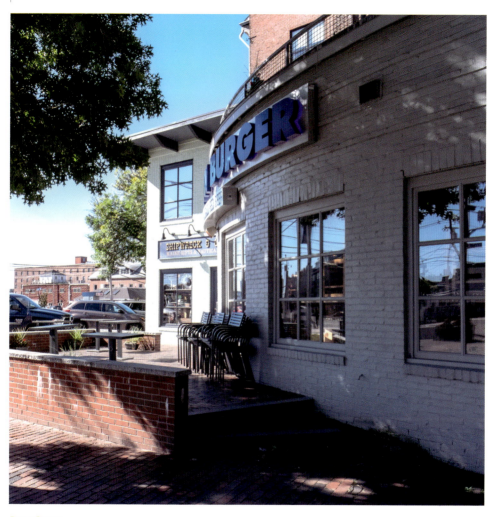

Dana Street

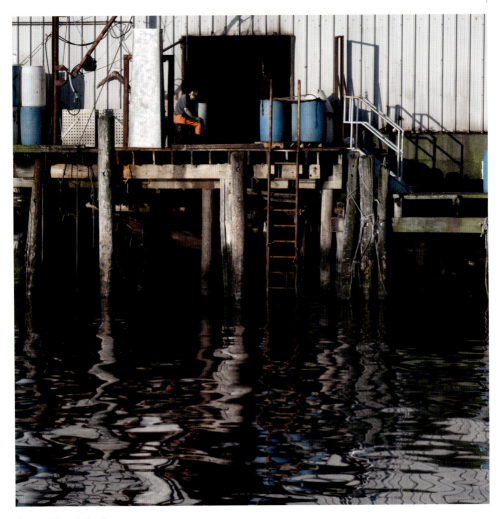

Custom House Wharf

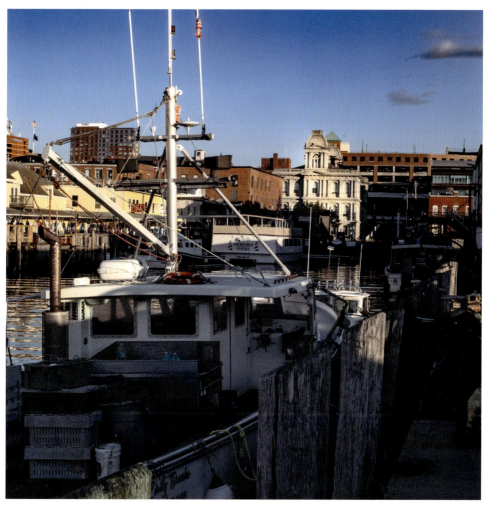

Maine Wharf

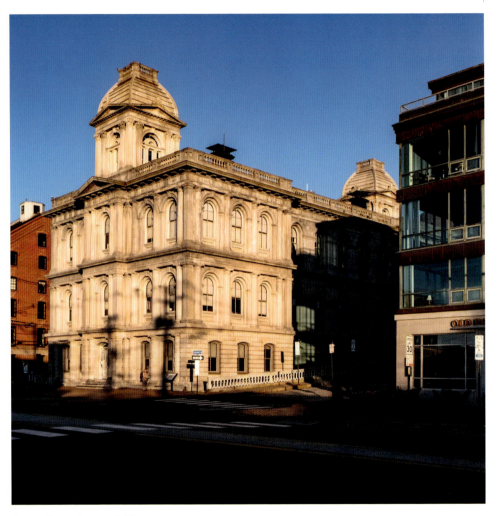

Custom House, Commercial Street

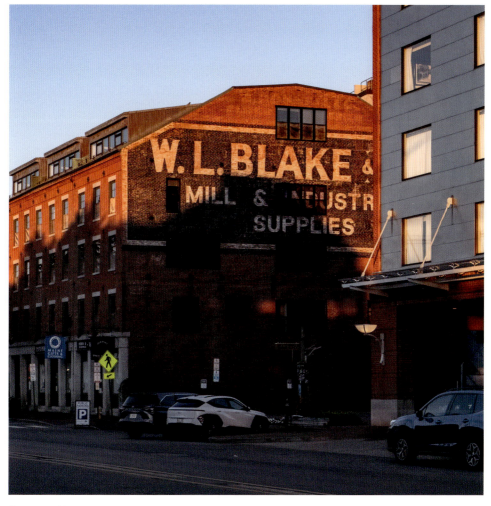

Commercial Street

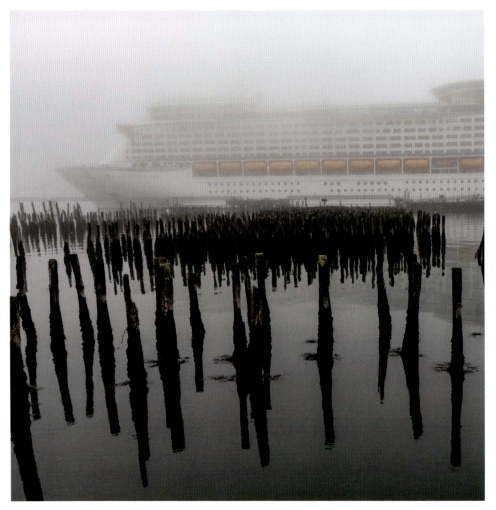

Portland Ocean Gateway

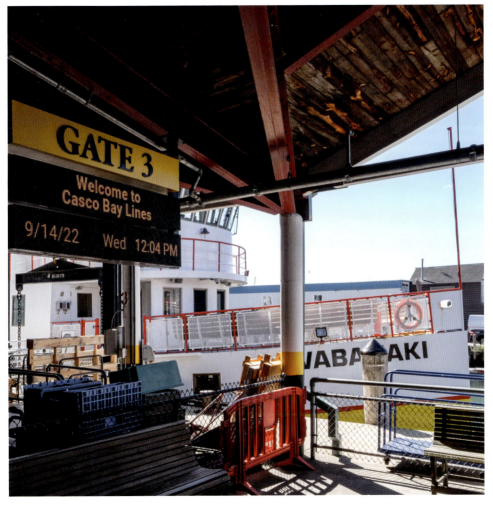

Casco Bay Lines, Maine State Pier

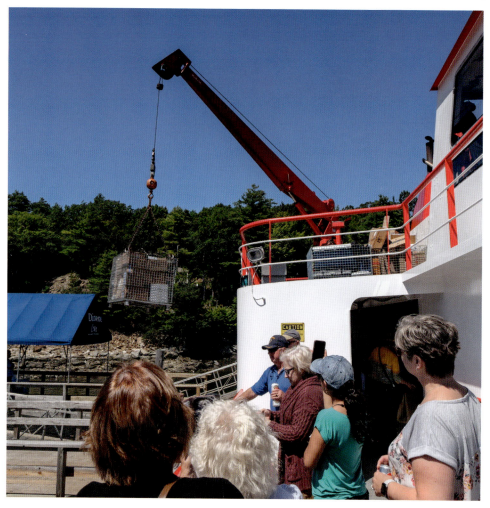

Diamond Cove, Great Diamond Island

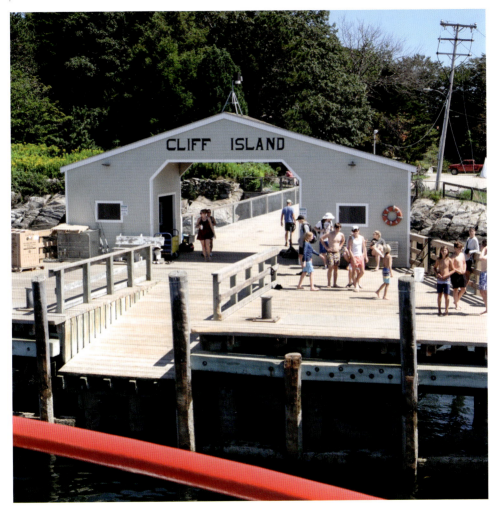

Cliff Island

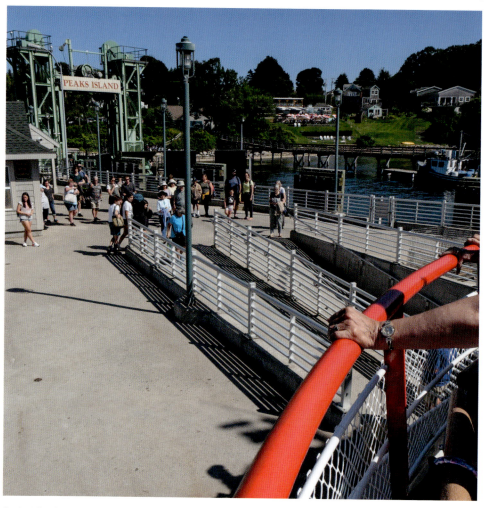

Peaks Island

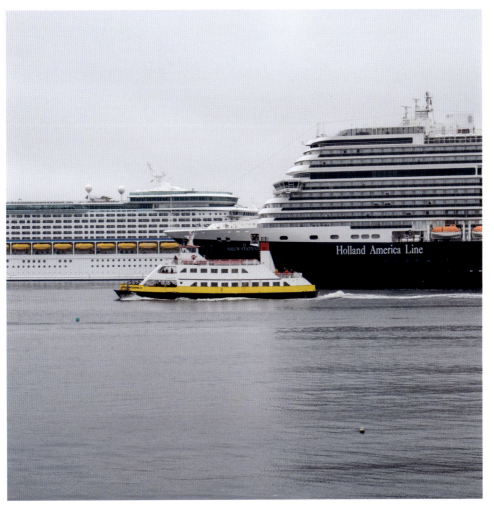

Portland Harbor

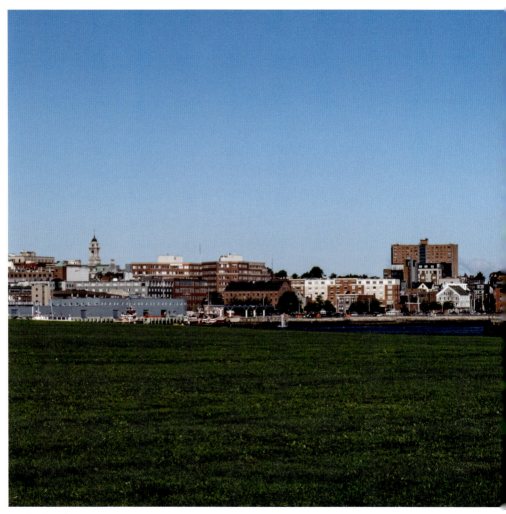

Portland Harbor

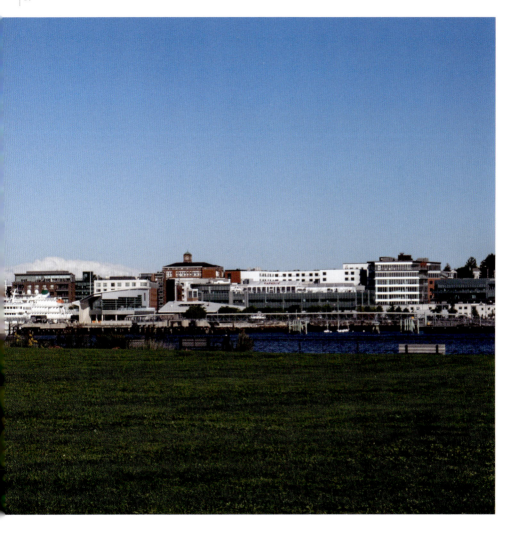

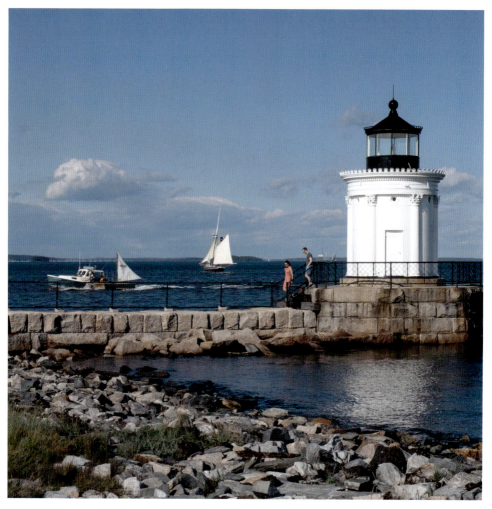

Bug Light, Bug Light Park, South Portland

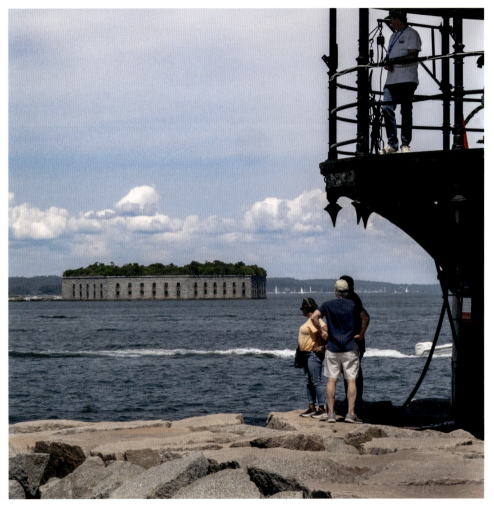

Fort Gorges, Spring Point Ledge Lighthouse, South Portland

Liberty Ship Memorial, Bug Light Park

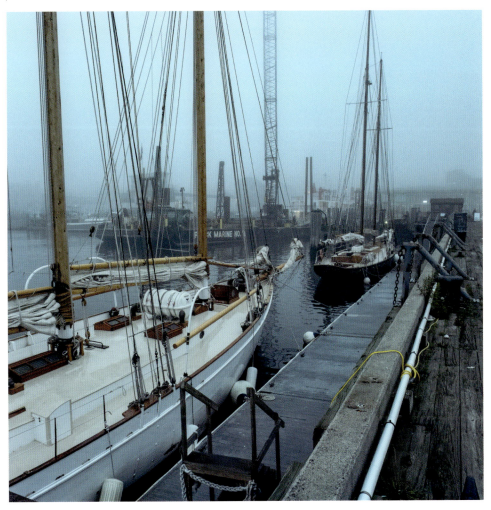

Maine State Pier

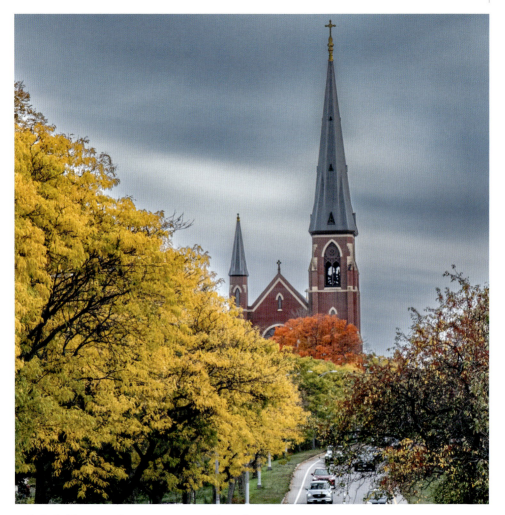

Cathedral of the Immaculate Conception, Franklin and Congress Streets

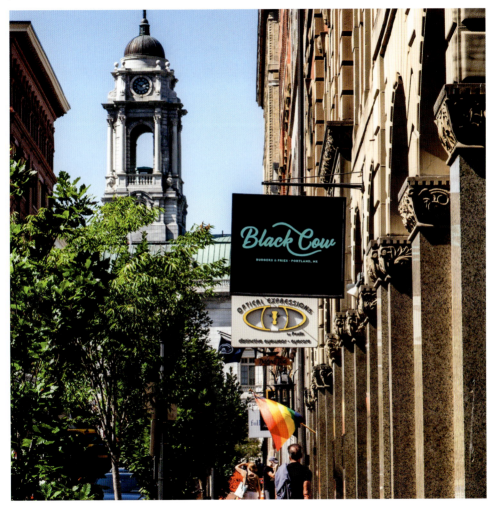

Exchange Street

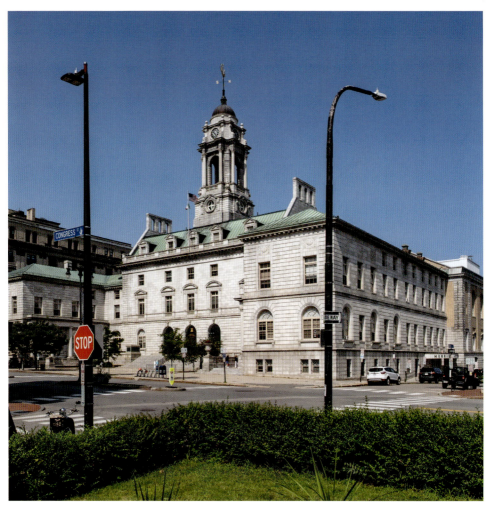

City Hall, Congress Street

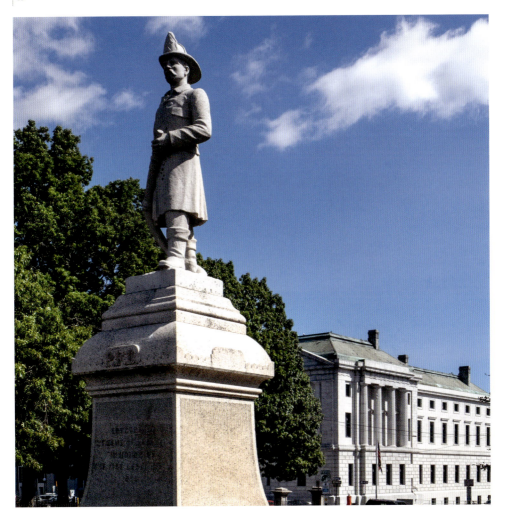

In honor of the city's firemen, Congress Street

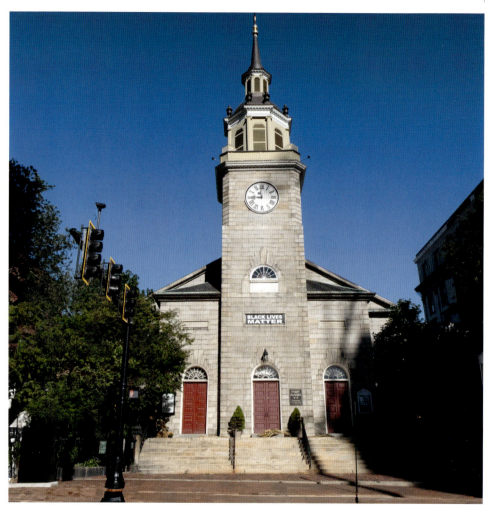

Portland Unitarian Universalist Church, Congress Street

Lincoln Park, Congress Street

Granite and brick

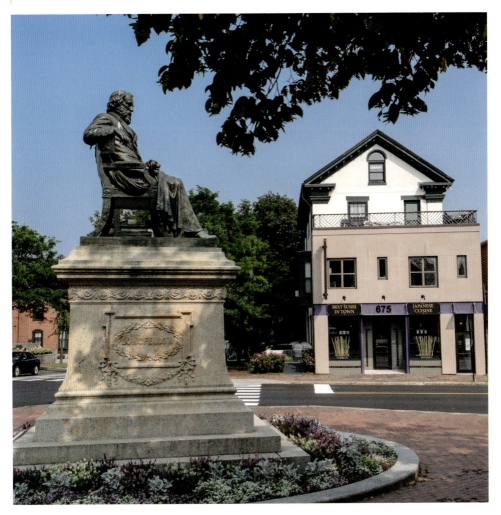

Henry Wadsworth Longfellow Monument, State and Congress Streets

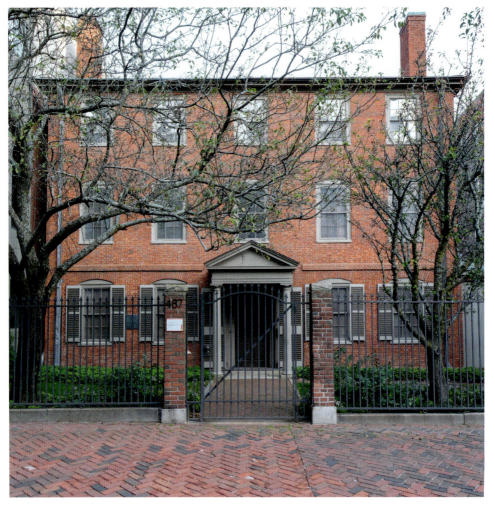

Maine Historical Society, Wadsworth-Longfellow House, Congress Street

Monument Square, Federal Street

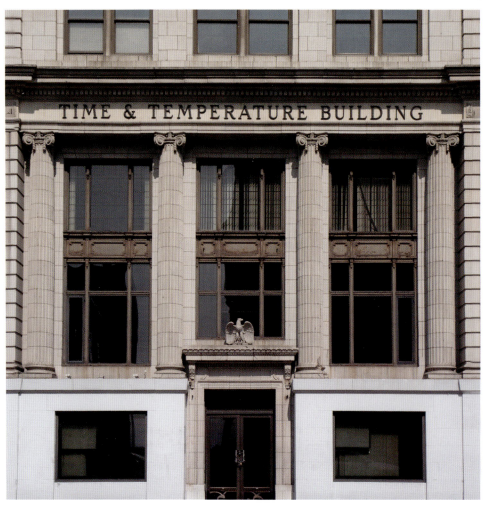

Monument Square, Congress Street

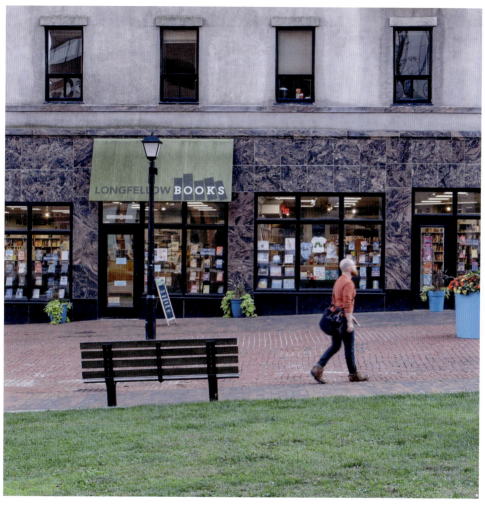

Monument Square

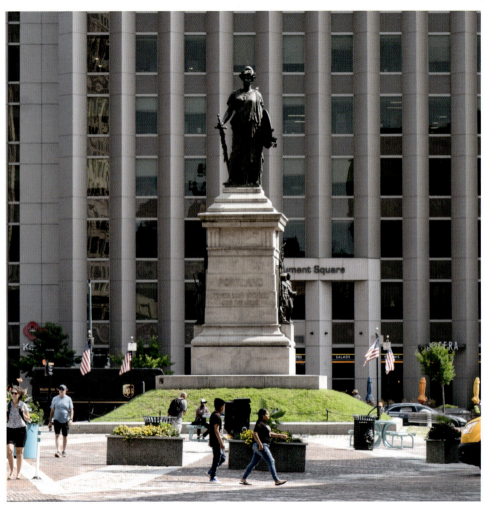

Our Lady of Victories, Monument Square

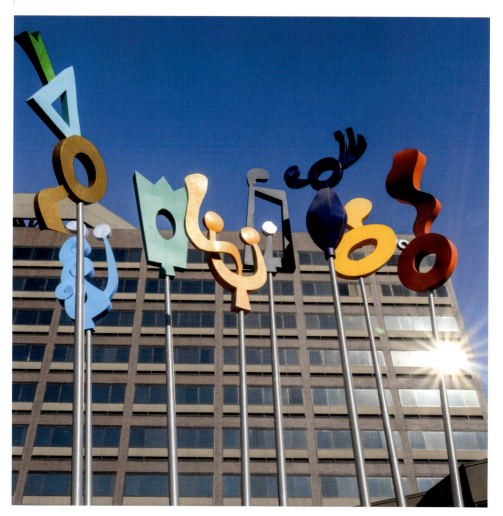

Congress Street

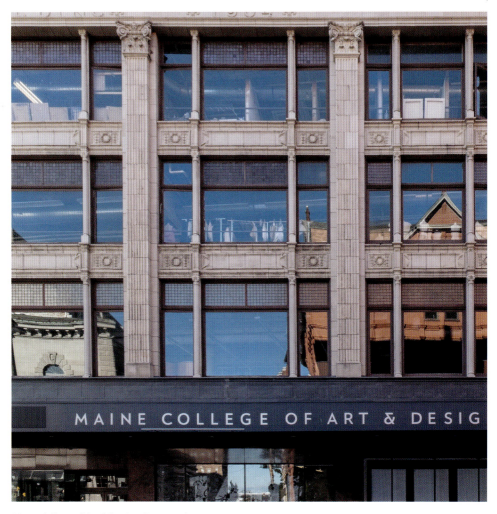

Maine College of Art & Design, Congress Street

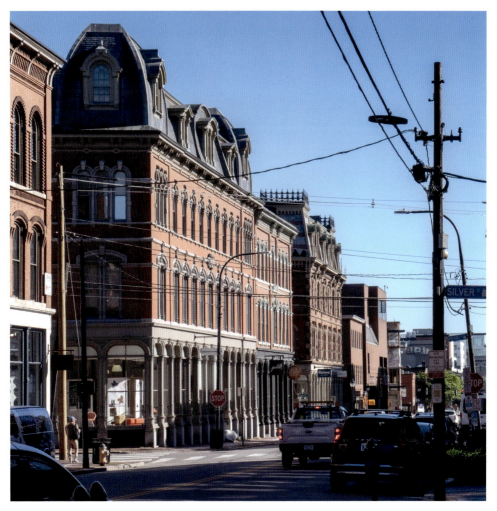

Middle Street

Middle Street

Market Street

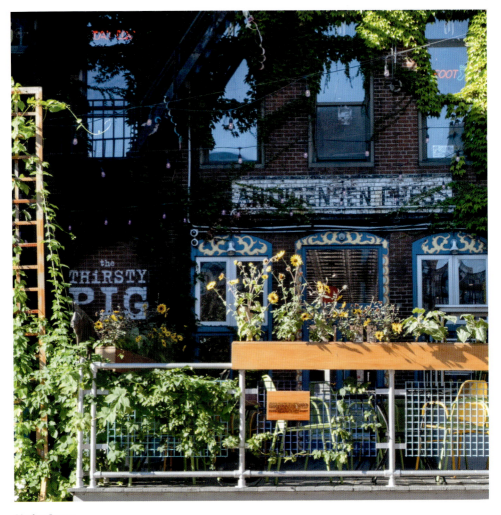

Market Street

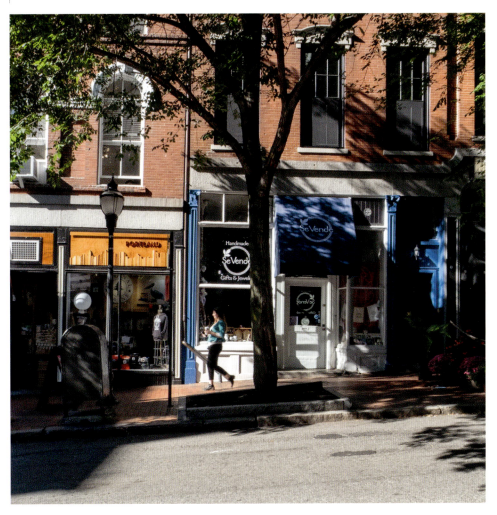

Exchange Street

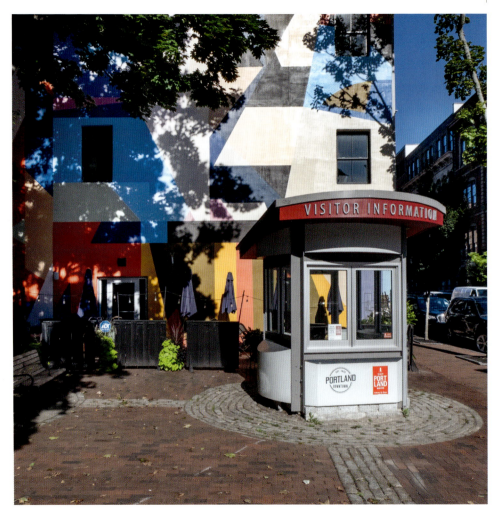

Tommy's Park, Exchange and Middle Streets

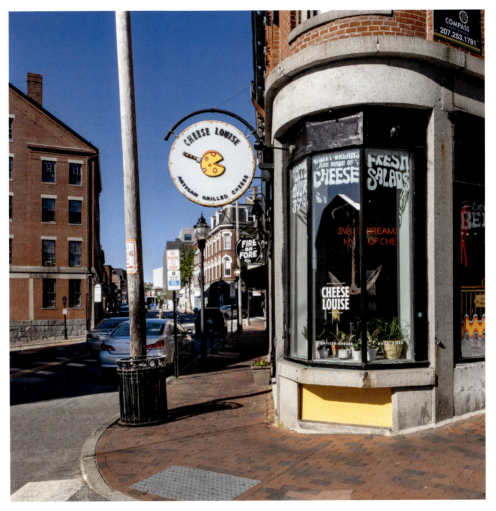

Fore Street

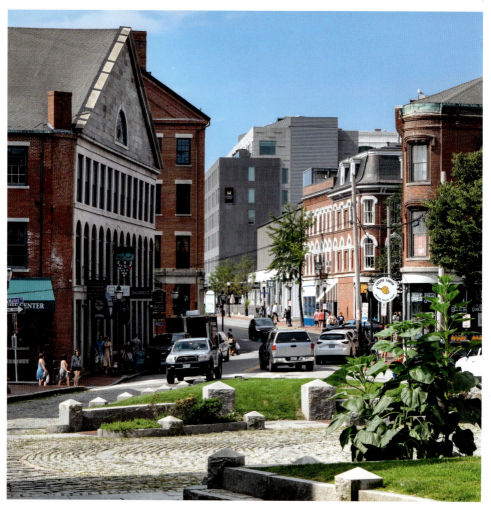

Fore Street

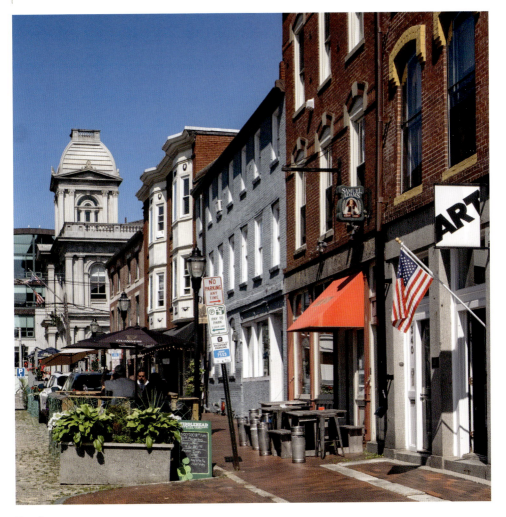

Fore Street

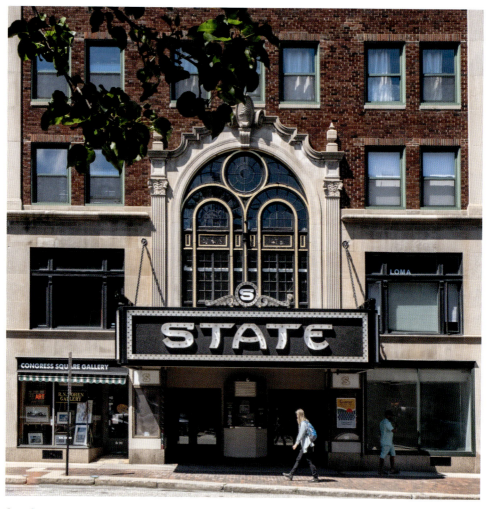

State Street

Spring Street

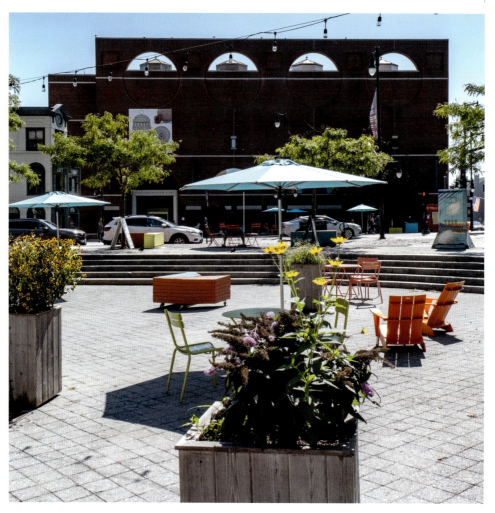

Congress Square Park, Portland Museum of Art

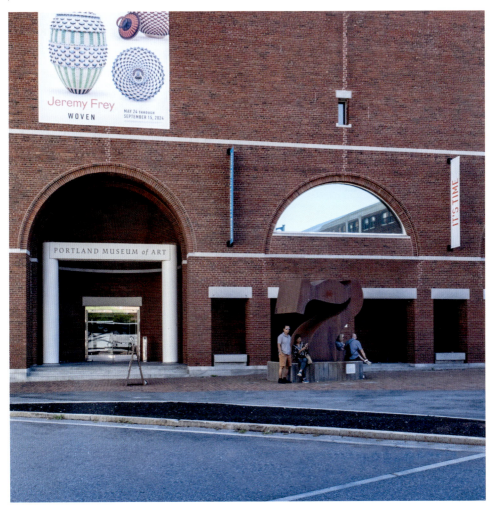

Portland Museum of Art, Congress Street

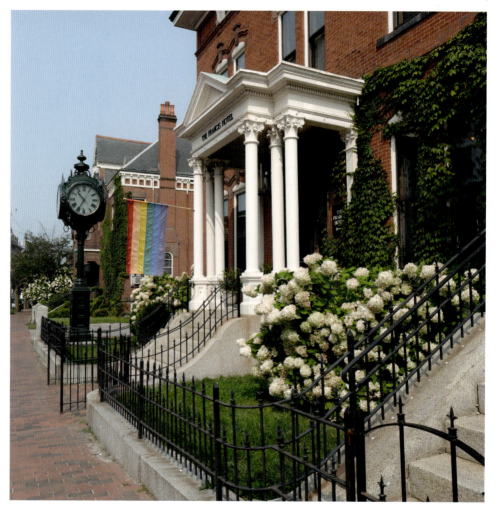

The Francis Hotel, Congress Street

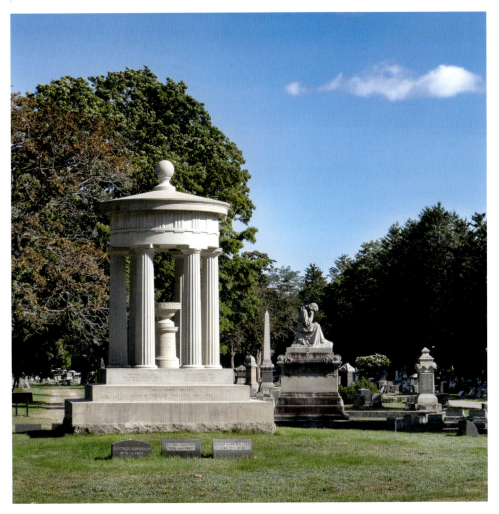

Evergreen Cemetery, Stevens Avenue

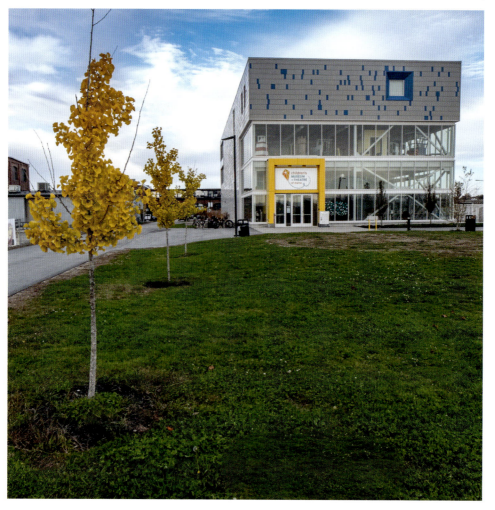

Children's Museum & Theatre of Maine, Thompson's Point

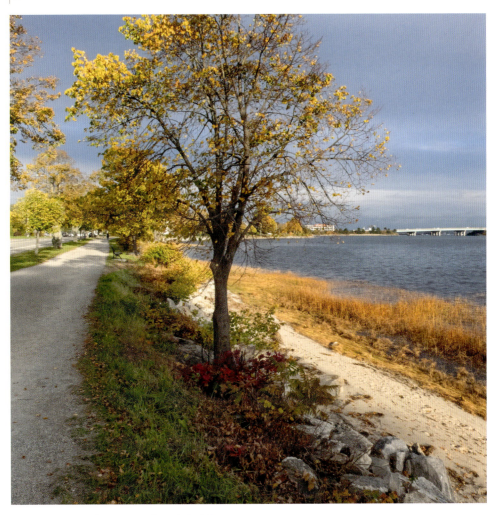

Edward Payson Park, Baxter Boulevard, Back Cove

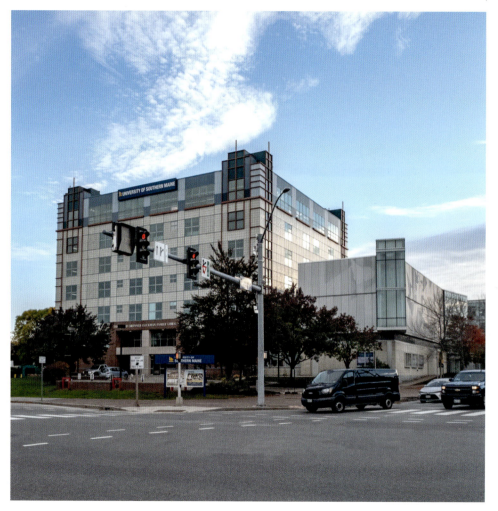

University of Southern Maine, Forest Avenue

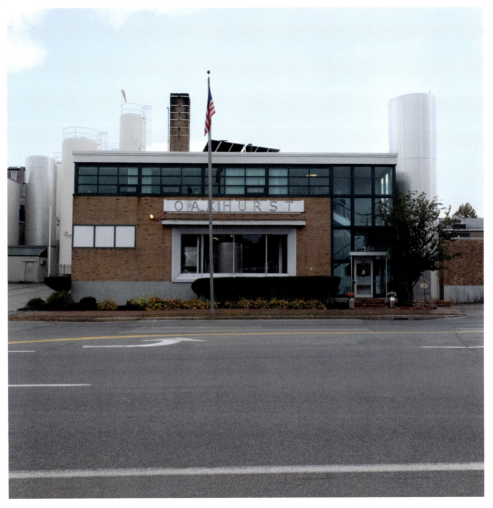

Oakhurst Dairy, Forest Avenue

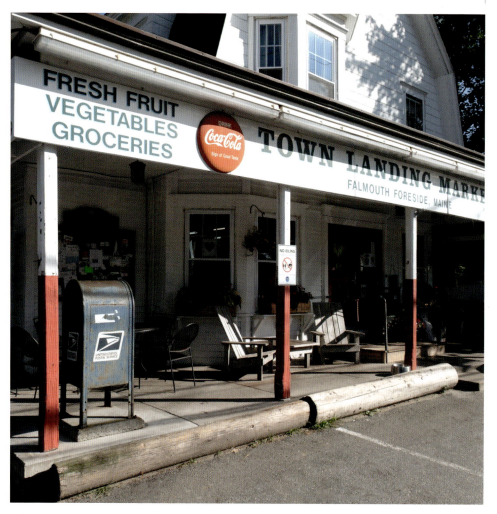

Falmouth Foreside, Route 88

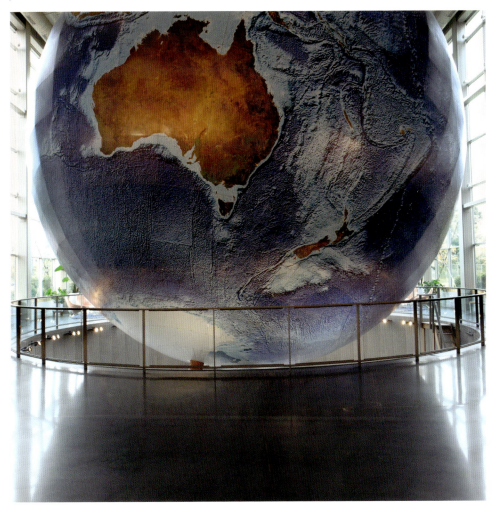

Garmin, DeLorme, Falmouth

Bug Light Park

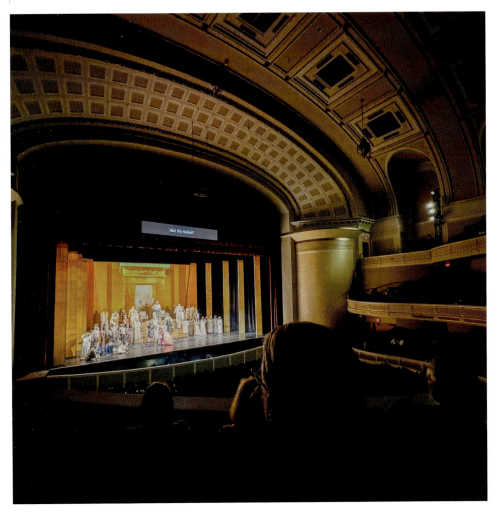

Opera Maine, Merrill Auditorium, Elm Street

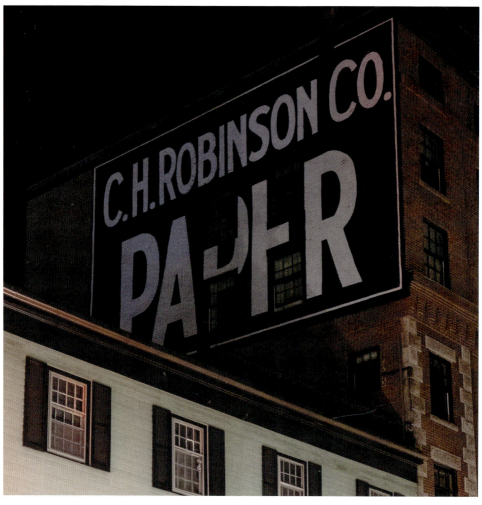

Moulton Street

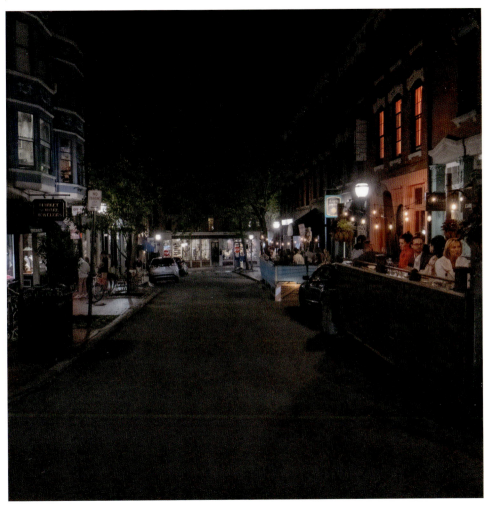

Exchange Street

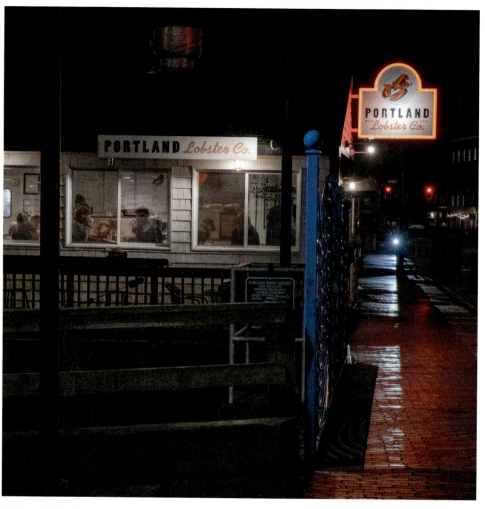

Commercial Street

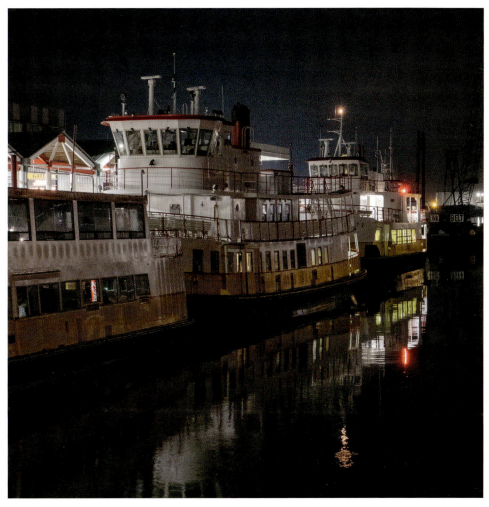

Maine State Pier

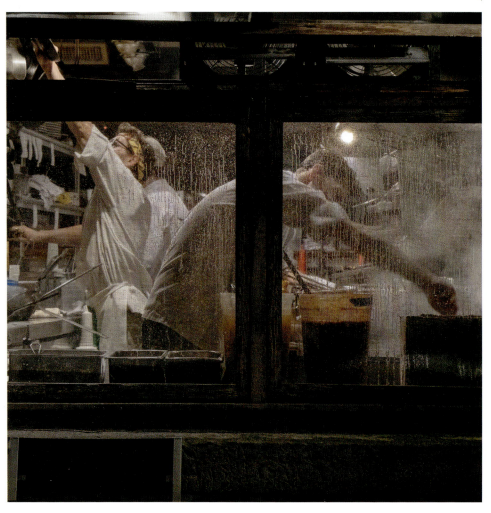

Wharf Street

Commercial Street

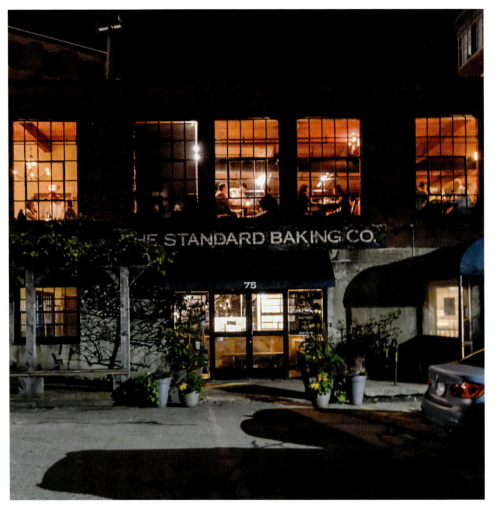

Fore Street Restaurant above Standard Baking Co.

Milk Street

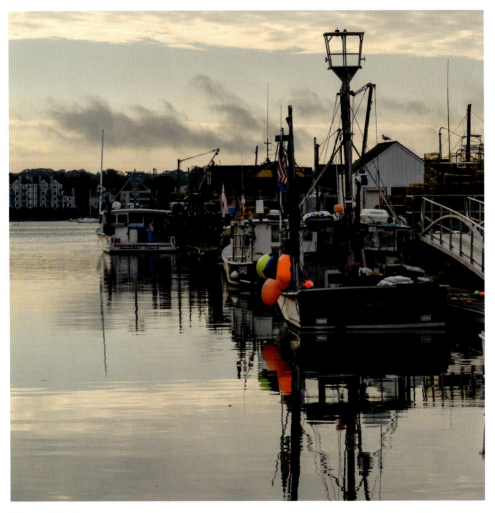

Widgery Wharf

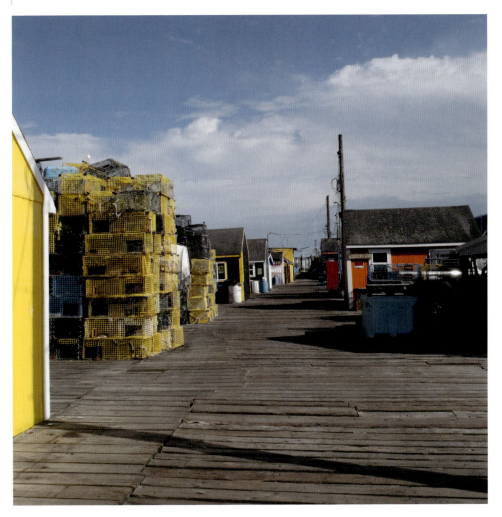

Widgery Wharf

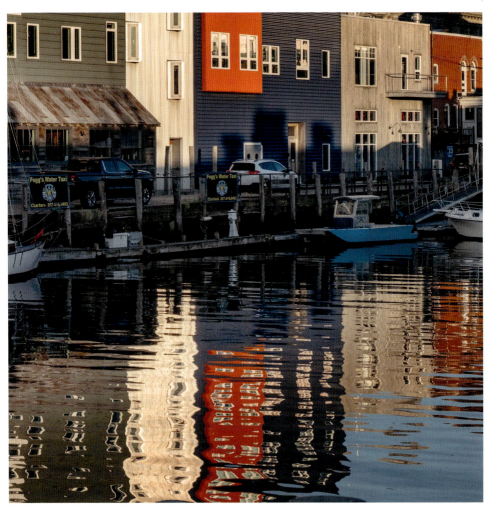

Maine Wharf

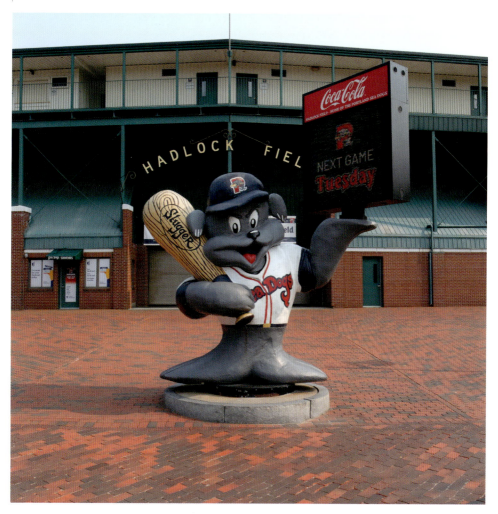

Hadlock Field, Park Avenue

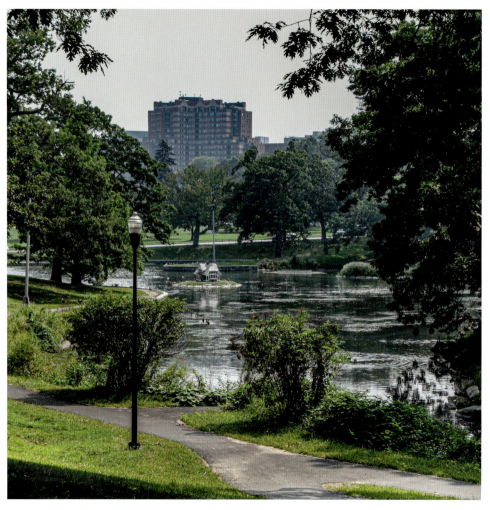

Deering Oaks Park

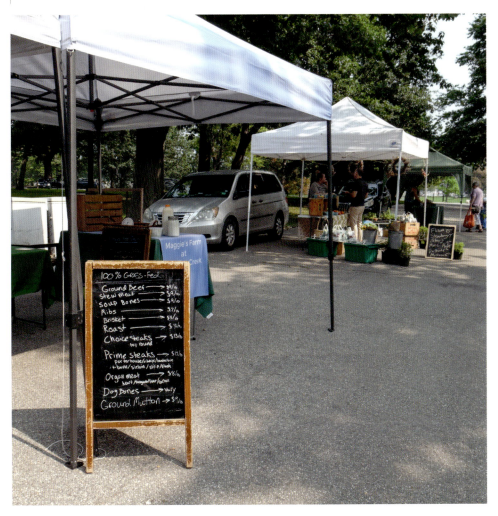

Farmers' market, Deering Oaks Park

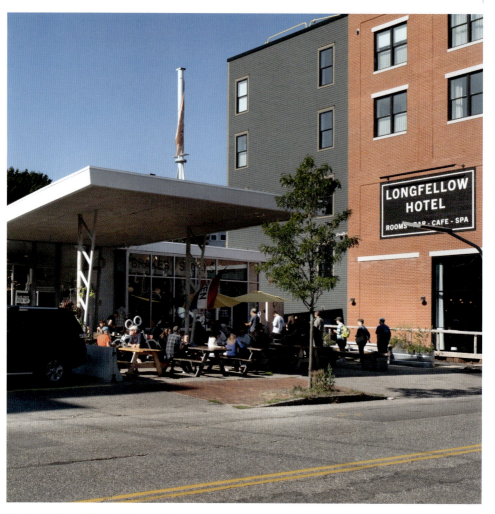

Tandem Coffee and Bakery, Congress Street

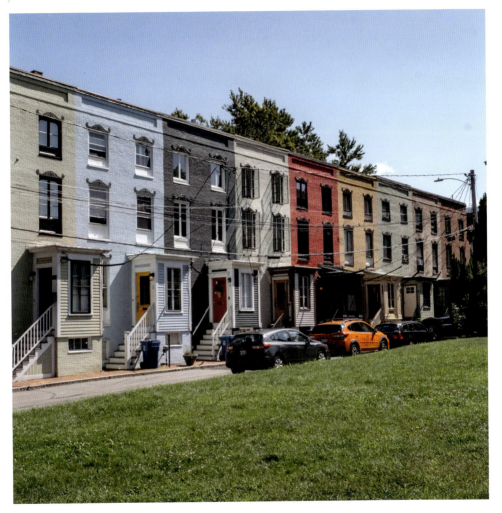

Stratton Place

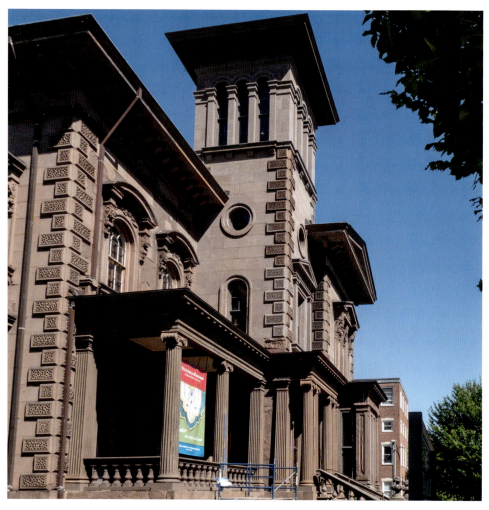

Victoria Mansion, Danforth Street

Deering Street

Vaughan Street

Western Promenade

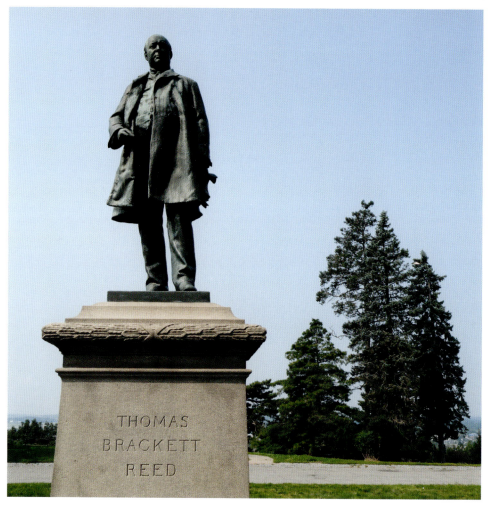

Thomas Brackett Reed Memorial, Western Promenade

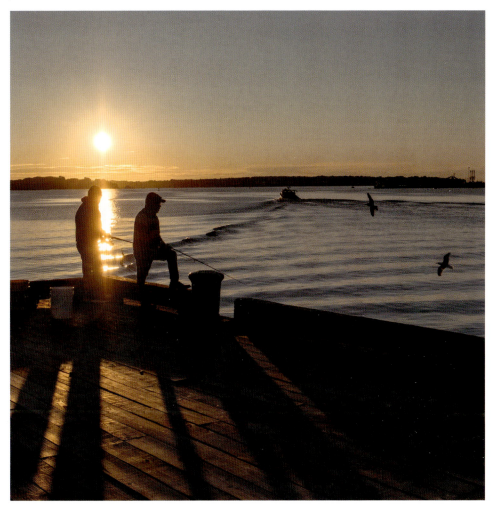

Maine State Pier

Antelo Devereux Jr. has been photographing for the better part of his life, first as an amateur and more recently as a professional. He has published eleven travel-oriented books and has exhibited his images in various venues and galleries in Maine, Vermont, Pennsylvania, and Delaware. He has degrees from Harvard University and the University of Pennsylvania and has studied at Maine Media Workshops. He lives with his family in Chester County, Pennsylvania, and spends summers in Maine. His photographs can be seen on Instagram @photoeye1.

OTHER **SCHIFFER BOOKS** BY THE AUTHOR:

Maine: A Keepsake, 978-0-7643-6742-7

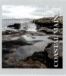

Coastal Maine: A Keepsake, 978-0-7643-5575-2

OTHER **SCHIFFER BOOKS** ON RELATED SUBJECTS:

The Maine Coast, Michael Kahn 978-0-7643-6811-0

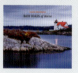

Back Roads of Maine, David Skernick, 978-0-7643-6747-2

Copyright © 2025 by Antelo Devereux Jr.

Library of Congress Control Number: 2024942480

All rights reserved. No part of this work may be reproduced or used in any form or by any means—graphic, electronic, or mechanical, including photocopying or information storage and retrieval systems—without written permission from the publisher.

The scanning, uploading, and distribution of this book or any part thereof via the Internet or any other means without the permission of the publisher is illegal and punishable by law. Please purchase only authorized editions and do not participate in or encourage the electronic piracy of copyrighted materials.

"Schiffer," "Schiffer Publishing, Ltd.," and the pen and inkwell logo are registered trademarks of Schiffer Publishing, Ltd.

Designed by Alexa Harris
Cover design by Danielle D. Farmer

Type set in Bell MT/Bodoni URW

ISBN: 978-0-7643-6913-1
Printed in China

Published by Schiffer Publishing, Ltd.
4880 Lower Valley Road
Atglen, PA 19310
Phone: (610) 593-1777; Fax: (610) 593-2002
Email: info@schifferbooks.com
Web: www.schifferbooks.com

For our complete selection of fine books on this and related subjects, please visit our website at www.schifferbooks.com. You may also write for a free catalog.

Schiffer Publishing's titles are available at special discounts for bulk purchases for sales promotions or premiums. Special editions, including personalized covers, corporate imprints, and excerpts, can be created in large quantities for special needs. For more information, contact the publisher.